KARATE BOY

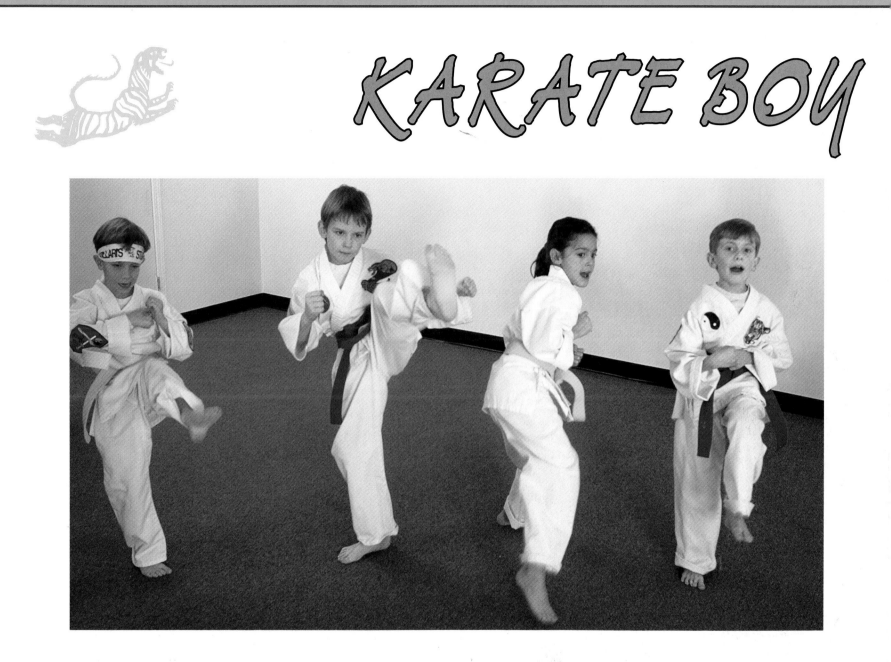

Ann Morris · *photographs by* David Katzenstein

DUTTON CHILDREN'S BOOKS NEW YORK

We wish to thank Chief Instructor Joseph Biele at the Villari Self-Defense School and all the children in his class—particularly David and Georgie—and all the Asch family for their help. Without their enthusiasm and cooperation, this book would not have been possible.

Text copyright © 1996 by Ann Morris
Photographs copyright © 1996 by David Katzenstein

Library of Congress Cataloging-in-Publication Data

Morris, Ann, date.
Karate boy / by Ann Morris; photographs by David Katzenstein.—1st ed.
p. cm.
Summary: Explains what the sport of karate is and shows what happens in a typical karate class.
ISBN 0-525-45337-7 (hc)
1. Karate for children—Juvenile literature. [1.Karate.] I. Katzenstein, David, ill. II. Title.
GV1114.32.M67 1996 796.815—dc20 95-45683 CIP AC

Published in the United States 1996 by Dutton Children's Books,
a division of Penguin Books USA Inc.
375 Hudson Street, New York, New York 10014
Designed by Amy Berniker
Printed in Hong Kong First Edition
10 9 8 7 6 5 4 3 2 1

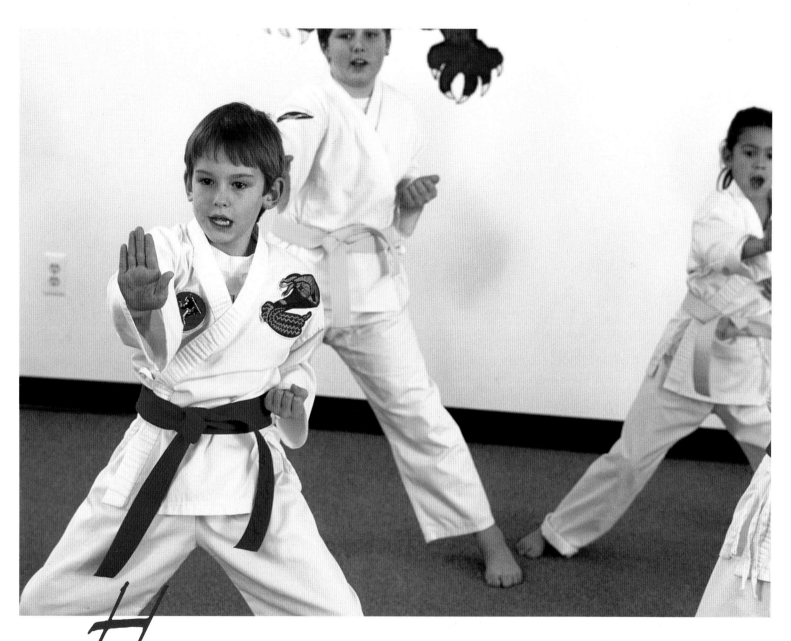

"*Hai*," says David. *Hai* means "yes" in Japanese. It's a word often used in his karate class. When David says *"Hai,"* he feels full of energy—ready for all the movements and exercises that are part of the karate way.

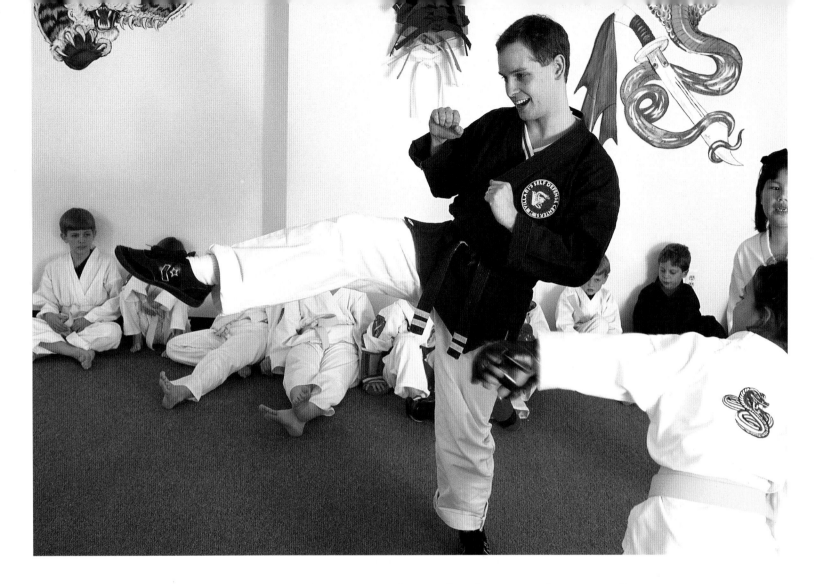

Karate has a long history, and David is happy to be part of it. Karate first came from Asia, but today it is a popular form of exercise all over the world.

David takes karate lessons once a week at a *dojo,* a place where people learn and practice karate. The *dojo* is near his house, in New Jersey.

David's instructor, Joe, is called *sensei,* which means "teacher."

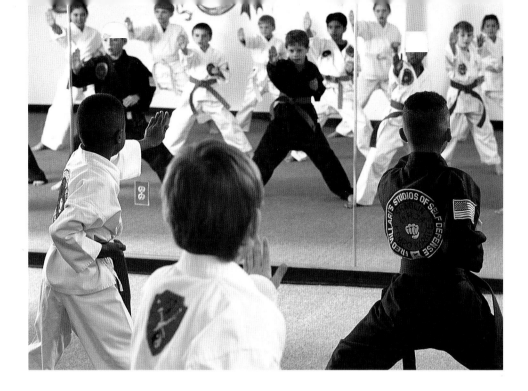

The other children in his class are around David's age, but people of all ages participate in this sport.

Georgie, his good friend, is in his class, too.

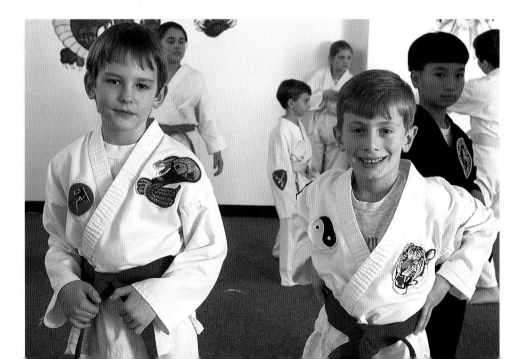

5

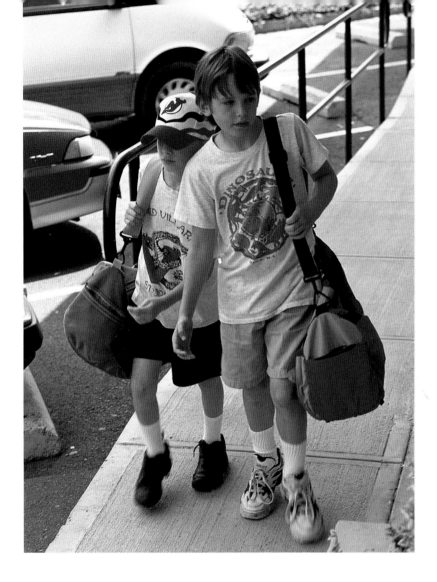

They've packed their clothes for class and are on their way to the *dojo*.

For class, David wears a simple white jacket and pants called a *gi*. This uniform is similar to the clothing that was worn by people in Japan long ago. It fits loosely so he can move easily. The pants have a drawstring, and the jacket closes with strings that tie together. Looking neat and clean is also part of the karate way.

The colored belt worn with the *gi* is called an *obi.* The color of the *obi* shows a student's rank. (The more students learn and perfect their skills, the higher they are ranked.) And the higher the rank, the darker the belt. At David's school, the first belt earned is colored white, then yellow, orange, purple, blue, green, brown, and black. Both white and black uniforms are worn, but only those students at the purple-belt level or higher may wear black.

As students develop more skills, they take a test to advance to the next level. People with black belts are called masters. Earning a black belt takes many years of study and practice.

David wears a blue belt on his *gi* now, but he hopes to take his green-belt test very soon.

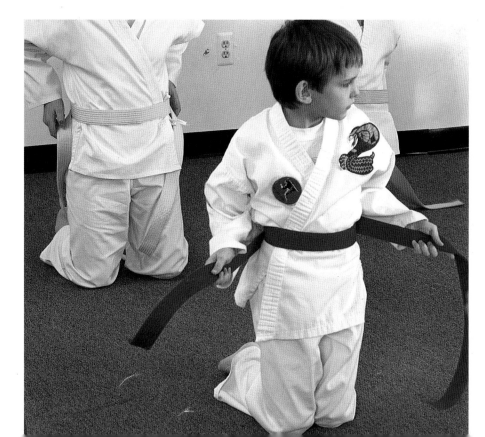

7

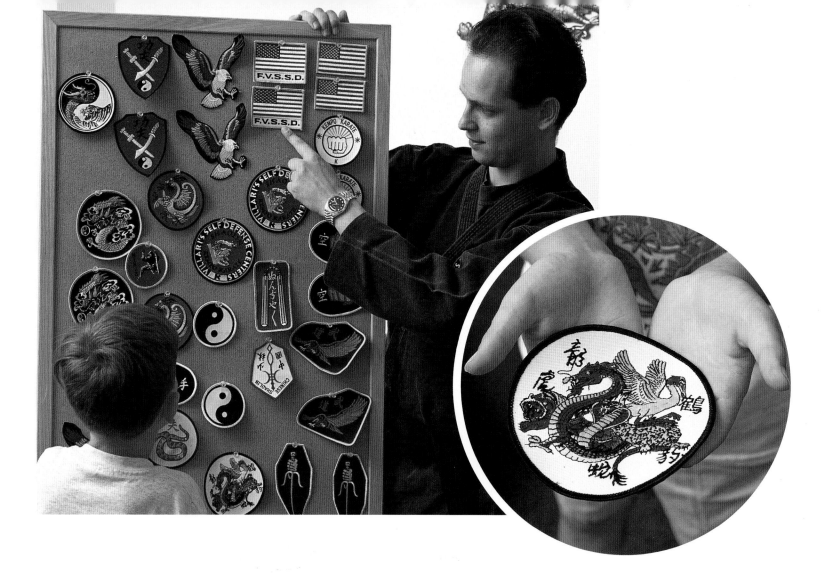

Animal patches representing different fighting styles are often sewn onto jackets. Many moves in karate were based on animal qualities and animal movements. The Tiger represents strength; the Leopard, speed and power; the Dragon, fighting spirit; the Crane, grace and balance; and the Snake, endurance and inner power.

Before class, David's teacher shows him many patches. David chooses a dragon to be sewn onto his jacket.

Karate is a system of fighting that uses only the body and the mind. It is based on an ancient tradition of combat that teaches the skills of fighting without weapons. Now it is practiced mainly as a sport. Karate teaches balance and body coordination and helps people keep fit and feel good about themselves.

But karate is more than a sport. It is a way of life, too. Joe has told the class that in karate what they do with their minds and what they do with their bodies are both important. He says they should be open-minded and humble in everything they do. He encourages them to put these rules into practice at home and at school.

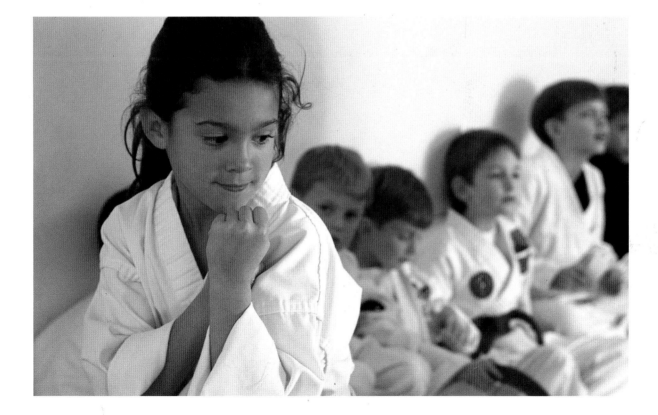

David lives with his mom and dad; his sister, Laura; and his baby brother, Andrew. He plays in his backyard and enjoys many different sports.

Karate is his favorite, and Georgie's, too. The two of them are ready
for class—and ready to learn.

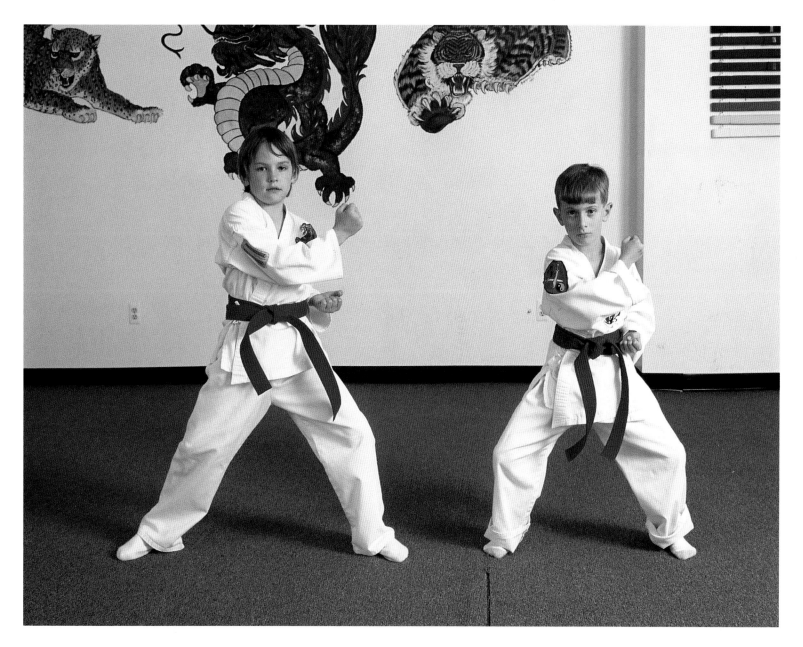

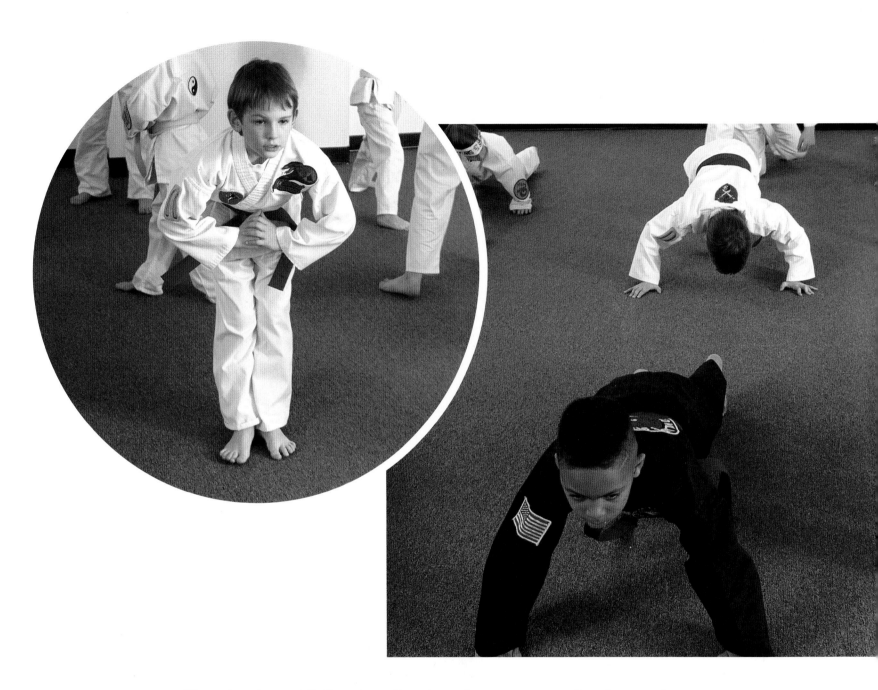

Class begins with bowing. Bowing shows respect for the teacher
and is part of the ancient tradition of karate.

Next come warm-up stretches. Everyone's muscles must be warmed up before the students begin their class activities.

Today Joe begins by teaching a punching exercise to the whole class. The students watch their teacher and themselves in the mirror and try to follow the movements correctly.

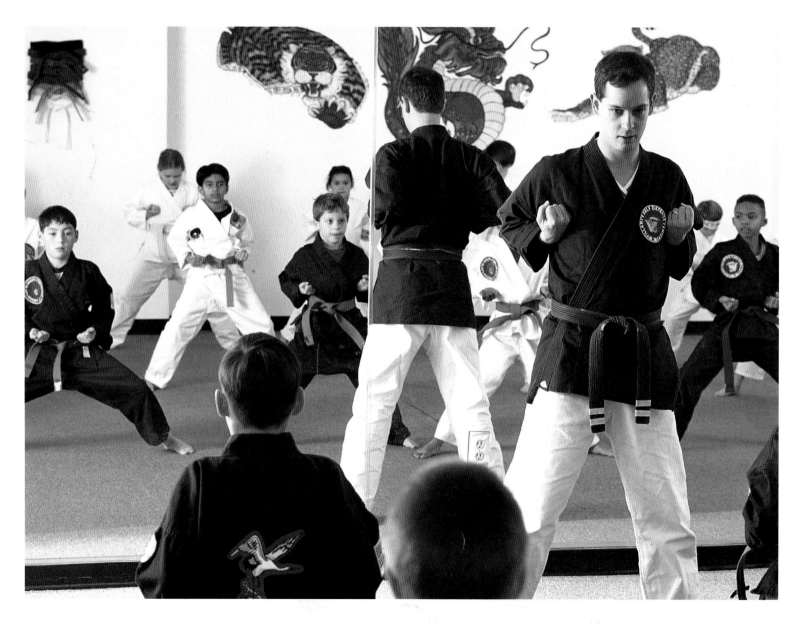

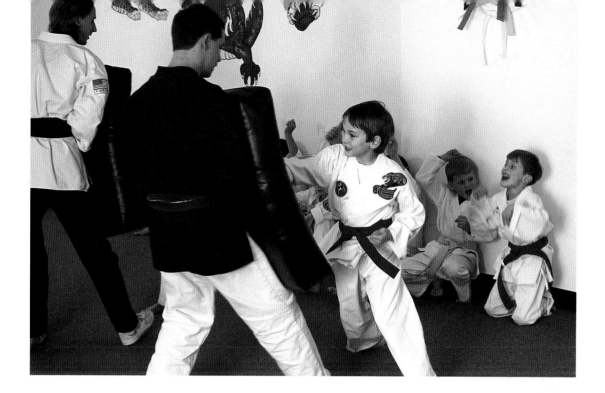

Then David takes his turn with the teacher. He does some kicking exercises, too.

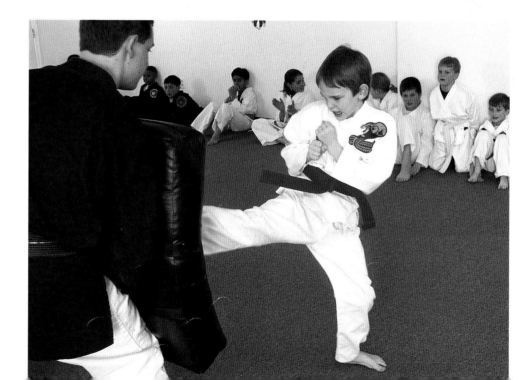

15

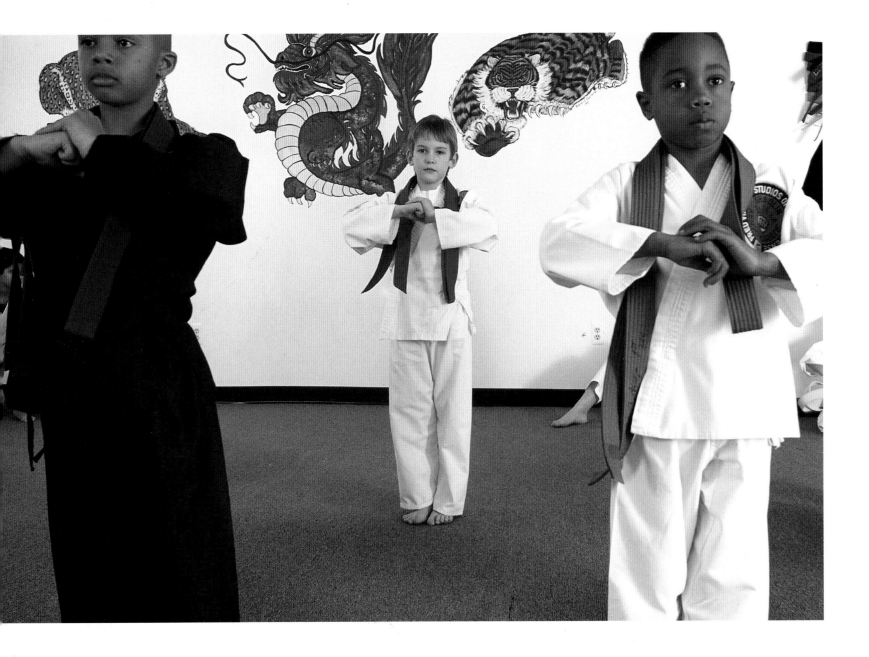

The students constantly work on their form—

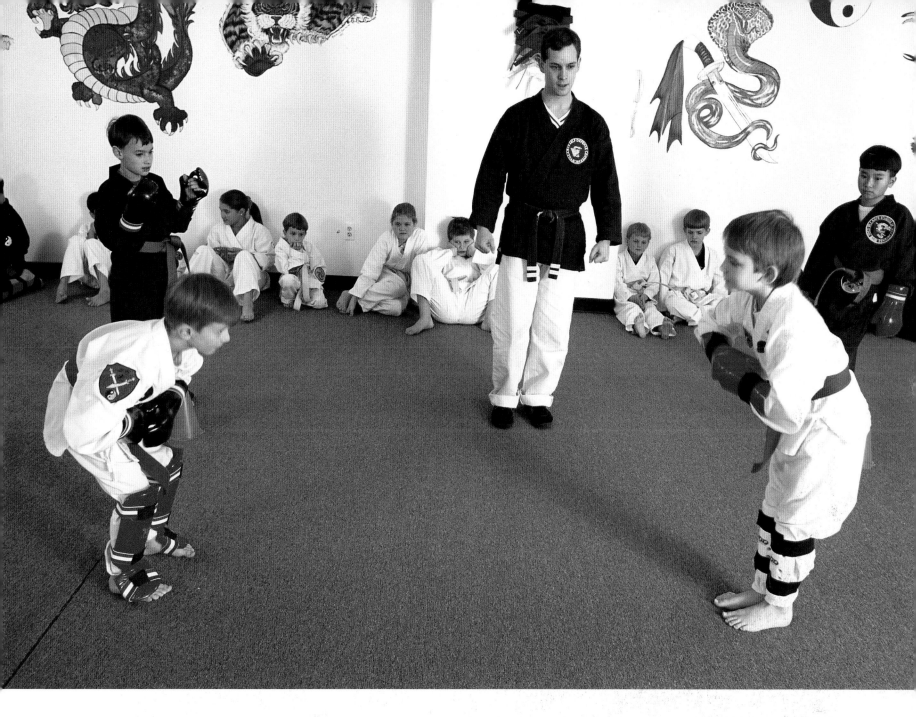

Before sparring, each partner bows. This shows their respect for each other.

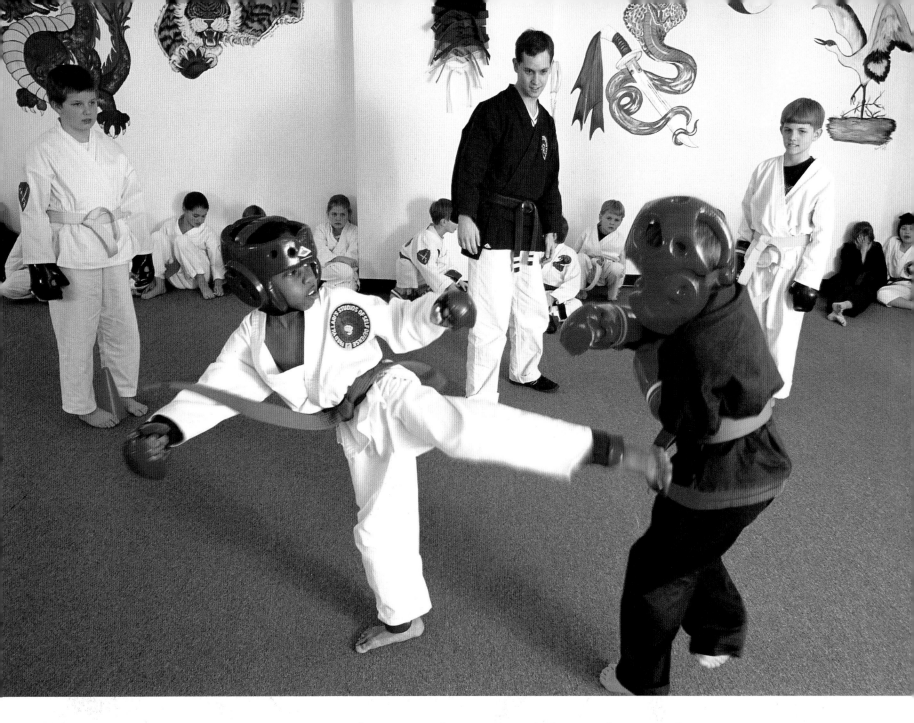

Protective gear is often worn for sparring. The teacher watches carefully whenever two students fight, to make sure no one gets hurt.

Both boys and girls attend the class. Here, the two sparring partners are girls.

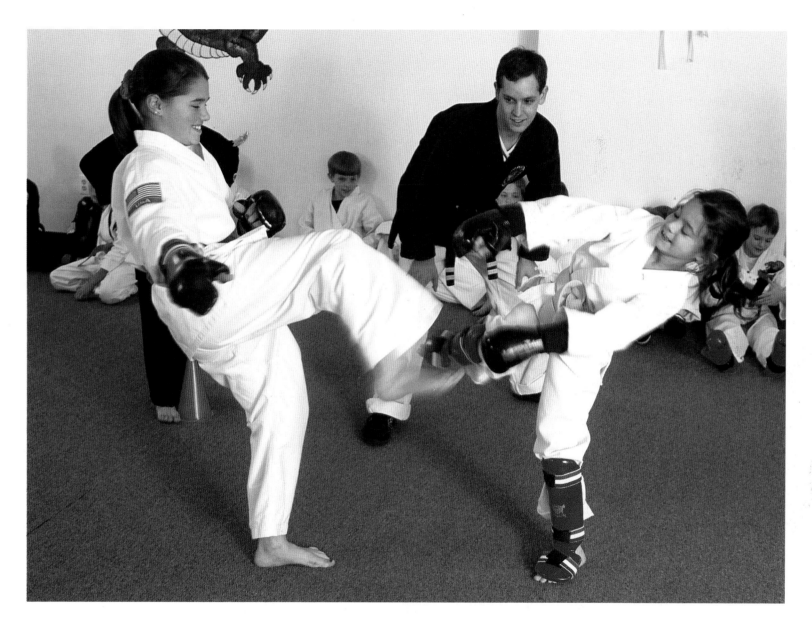

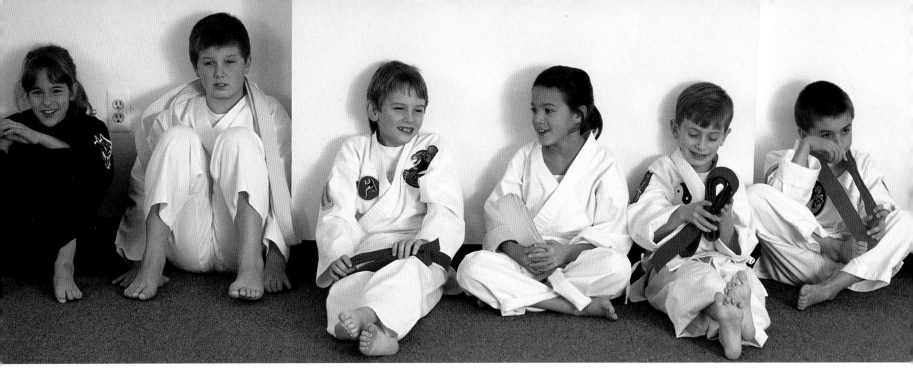

The students wait and watch one another. They listen to the teacher give directions...

and corrections.

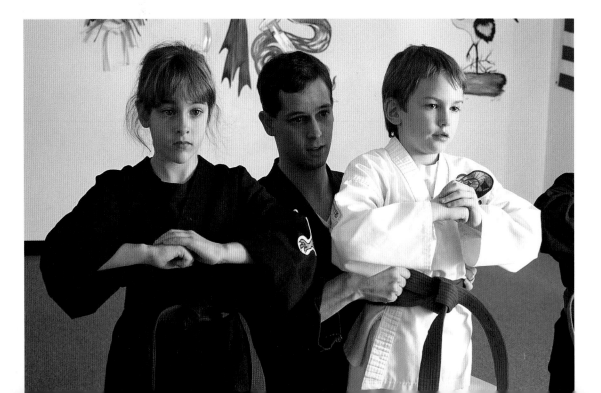

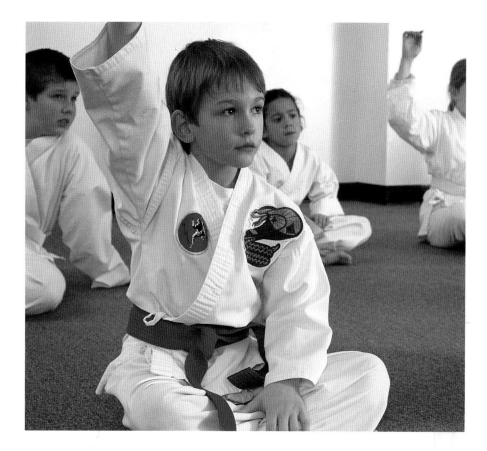

They raise their hands to answer questions about the rules of
the school.

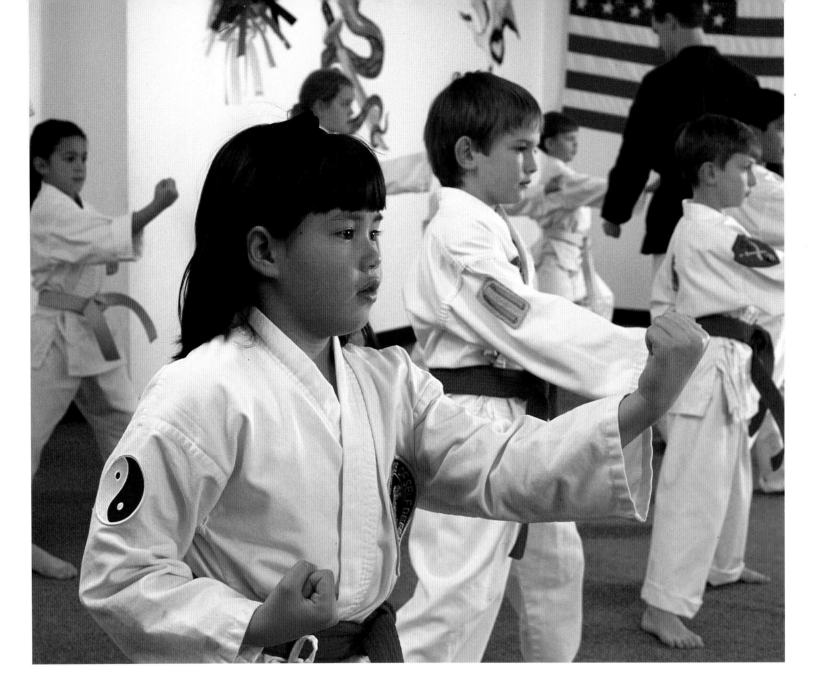

Karate students compete with themselves. They repeat the
exercises and movements over and over to make them perfect.
Each student aims to be the best he or she can be.

At the end of class, there is a time for meditation, which is quiet thought. Then the students bow again.

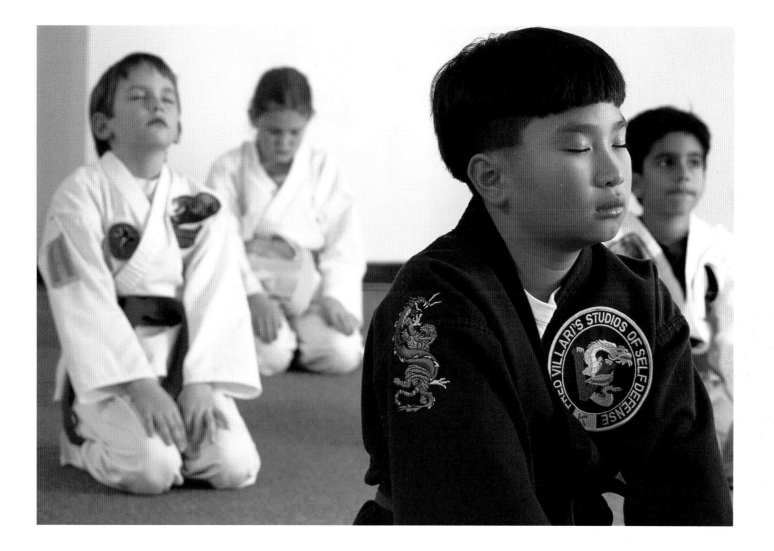

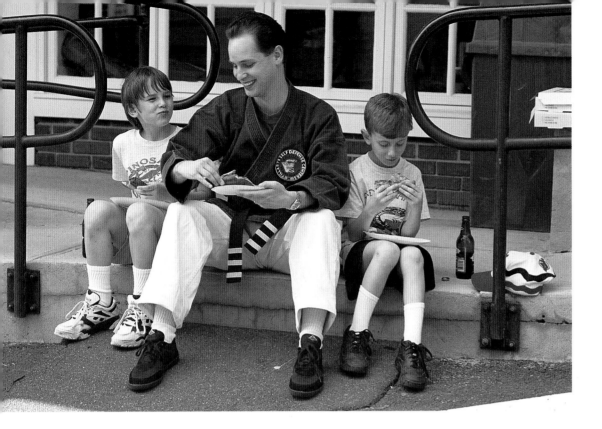

"I think it's time for the two of you to take your green-belt test," says Joe, over crunchy pizza. If they pass, Georgie and David can move to the next higher level.

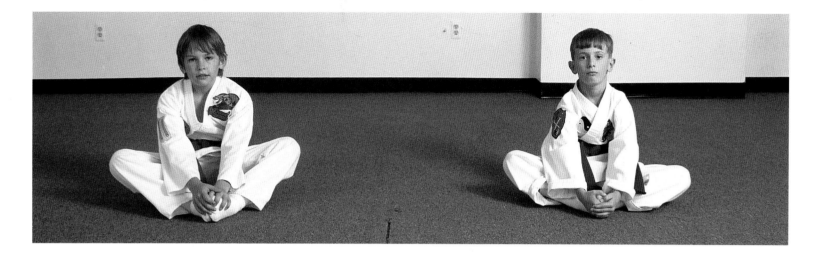

On the morning of the test, the boys are ready. Joe watches them
very carefully to see that each movement required is performed properly.
As part of their test, the boys do kicks ...

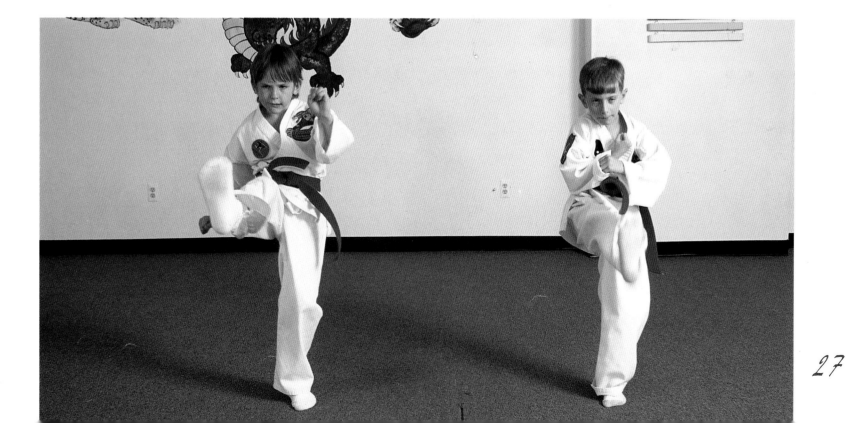

punches …

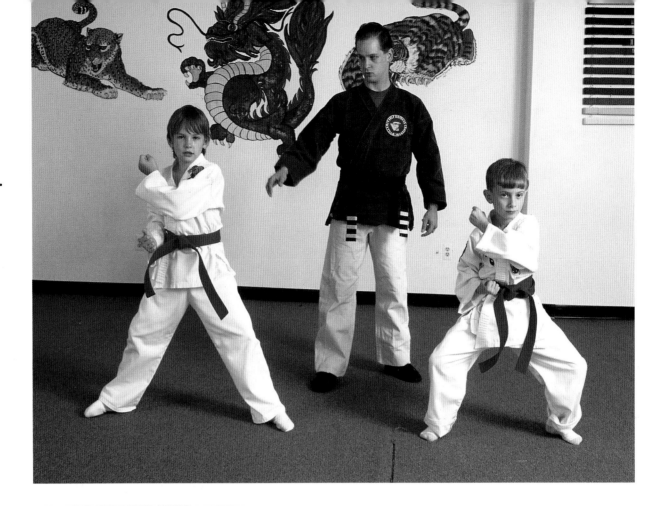

and blocks.

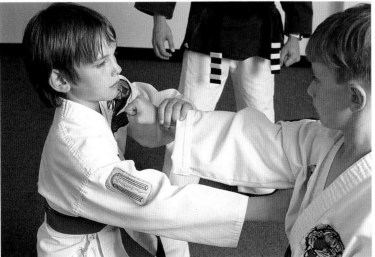

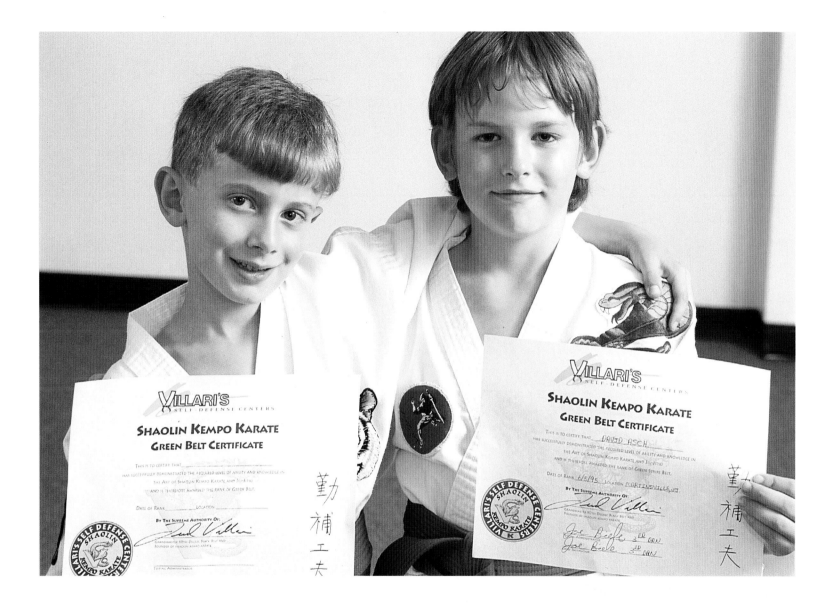

David and Georgie have earned their green belts.
"Congratulations," Joe says.
The boys show off their certificates.

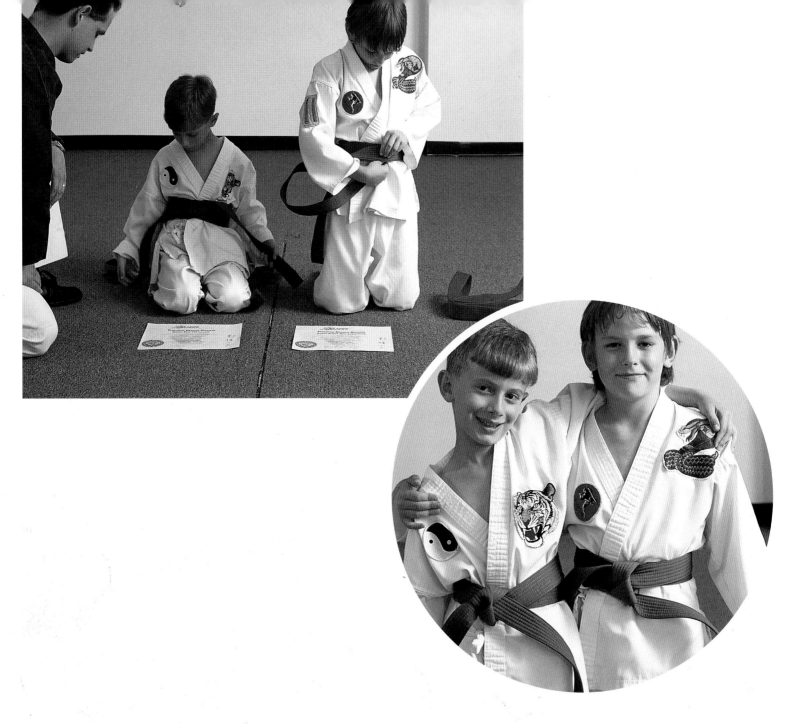

They change from blue to green belts. David thinks proudly of all he has learned on the way to his green belt.

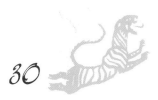

"We did it!" shouts David. *"Hai ya!"*

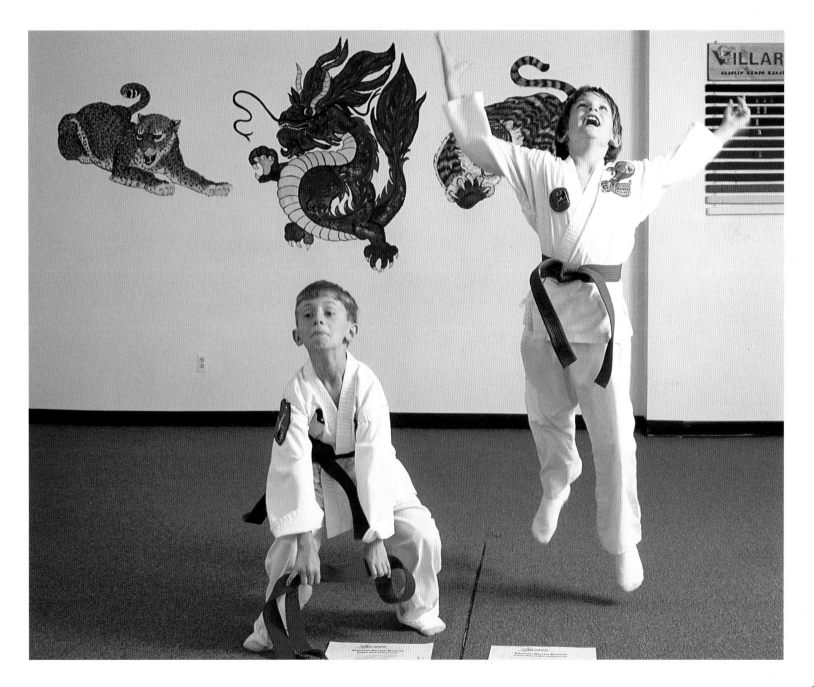

Glossary

dojo (DOH-jo): a place where people learn and practice karate

gi (gee): a loose-fitting jacket and pants that fasten with ties

hai (hi!): "yes" in Japanese

hai ya (hi-YAH!): "yes" with emphasis, in Japanese

karate (kah-RAH-tee): an ancient tradition of fighting that uses only
the body and the mind

meditation: quiet thought

obi (OH-bee): the colored belt that shows a student's rank

sensei (SEN-say): a karate teacher